T0012668

CUTE-O-RAMA

YOU CAN DOODLE ANYTHING!

FOR COLIN WEST. THANK YOU FOR INSPIRING
ME TO DRAW AS A CHILD, AND FOR BEING
A SUPPORTIVE AND KIND FRIEND TODAY. AND
TO MY BEST FRIEND AND HUSBAND, FERGUS.
YOU'RE THE BEST.

—G.S.

CUTE-O-RAMA. Copyright © 2024 by St. Martin's Press.
All rights reserved. Printed in China. For information, address
St. Martin's Publishing Group, 120 Broadway, New York, NY 10271.

www.castlepointbooks.com

The Castle Point Books trademark is owned by Castle Point Publishing, LLC.
Castle Point books are published and distributed by St. Martin's Publishing Group.

ISBN 978-1-250-33982-9 (trade paperback)

Illustrated by Grace Sandford
Design by Melissa Gerber
Edited by Aimee Chase

Our books may be purchased in bulk for promotional, educational, or
business use. Please contact your local bookseller or the Macmillan Corporate
and Premium Sales Department at 1-800-221-7945, extension 5442, or by email
at MacmillanSpecialMarkets@macmillan.com.

First Edition: 2024

10 9 8 7 6 5 4 3 2 1

CUTE-O-RAMA

YOU CAN DOODLE ANYTHING!

HOW TO DRAW MORE THAN

125

Super-Cute, Super-Easy Things

Grace Sandford

CASTLE POINT BOOKS
NEW YORK

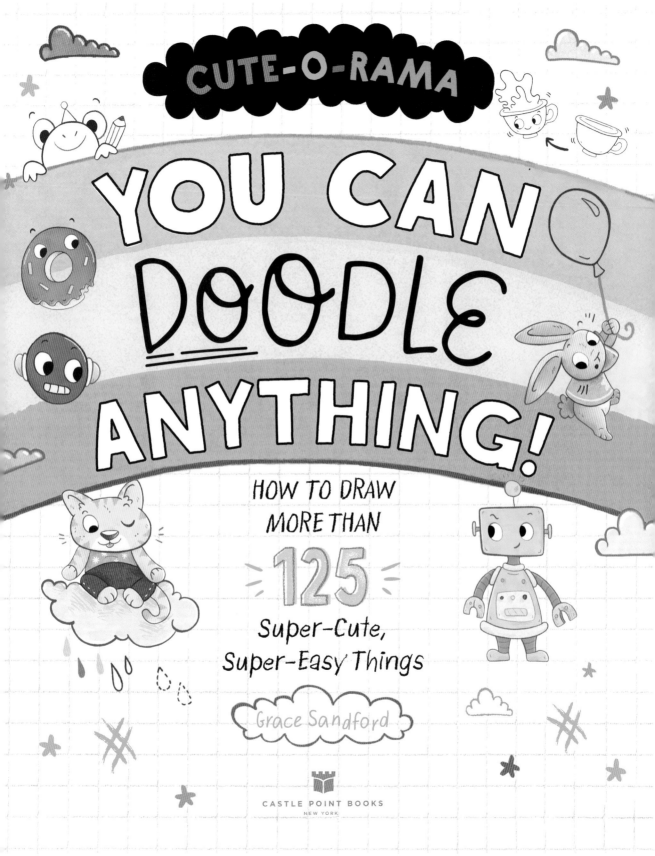

YOU CAN DOODLE...

iNTRoDUCTiON

Drawing is like...

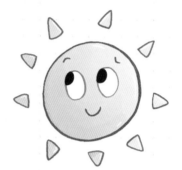

SUNSHINE. It's a perfect exercise for mindfulness and to improve your mood and mental health at any age. No matter how you are feeling, art is there for you. This is why I've always loved drawing. It's self-care. And it's good for the soul.

All you need in order to draw is...

A DRAWING tool AND A WILL to CREATE. No fancy materials or art background required. Find some paper and a way to make your mark. Literally. Get a pencil, a marker, a paintbrush—or even a pen you found under the couch—and doodle the day away.

Art is all about...

BEING YOURSELF. There are no other rules to follow, and that is what makes drawing so freeing. Add your own unique flair to the Cute-O-Rama doodles inside. Give that plant a grumpy face. Give that unicorn a ponytail. Everyone has an artist inside of them waiting to be let out.

Adorable things that make me happy are...

SUPER-CUTE ANIMALS! Especially cats and rabbits. You will see a few of them in this book. I also have lots of little figurines from my travels to Japan, and lots of cuddly toys, including my favorite one, a pink octopus.

Not everyone will appreciate your art...

KEEP GOING ANYWAY. I had an art teacher in high school who said I was not good enough. I almost stopped drawing because of it. But my love for drawing was stronger than that negative opinion. I knew I would have to work very hard to show the world the passion that I have for drawing. I went on to get an A and studied illustration at university. Don't let one person stop you from following your dreams!

LOVE YOUR DRAWINGS AND LOVE YOURSELF. Be proud of your creativity. Look ahead at all of the incredible things you are about to learn.

You can doodle anything!

JUST KEEP TRYING. Not everything you draw will come out the way you wanted. But the process of drawing is beneficial, no matter the result. Your brain is constantly learning from this process and working out how to improve. Keep a sketchbook so that you can look back and see how far you have come.

Cute-O-Rama Mantras

Repeat these phrases whenever you need a lift or a mood boost.

THERE'S NO ONE LIKE ME

Everyone has their own style. Celebrate the way your drawings differ from my drawings—and from friends who draw with you!

INSPIRATION IS EVERYWHERE

There's a whole world of cute out there. Stop to notice the weird and totally adorable things all around you.

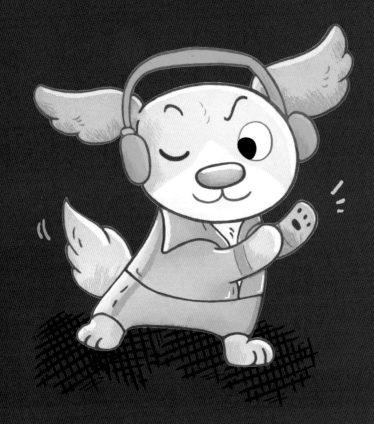

you can doodle like a pro

BUST A MOVE with these pro techniques and shortcuts for doodling success

What you'll need...

Simple supplies!

Whether you use the coolest pencils or ones you find at the bottom of your bag, you will be able to draw using this book. You can doodle on loose sheets of printer paper, the back of a receipt, or in a brand new sketchbook! This may sound strange, but using random scraps of paper can actually make you feel more free to experiment and make mistakes.

A can-do attitude!

Erasing a drawing or part of a drawing is sometimes more work than starting over, especially when you're making fun doodles like these. Instead, try to draw the same thing again and see how much you've improved from the last one! *

*But go ahead and use that eraser if it gives you confidence and joy. Your doodles, your rules.

Expressions

Draw faces with feelings!

Use these examples to add personality and pizzazz
to animals, food, and objects you want to cute-i-fy.

Happy

Excited

Sassy

Embarrassed

Shocked

Angry

Make your Mark

Fun with Shading!

Sometimes you want to add some flair, dimension, or a touch of texture. Here are some mark-making methods to try out as you experiment with cute doodles.

Hatching

Try covering an area with lots of lines.

Try hatching here!

Crosshatching

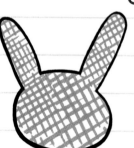

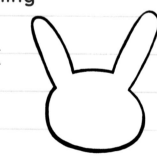

Start by hatching and then go over the top of the lines in another direction, like a cross.

Try crosshatching here!

Stippling

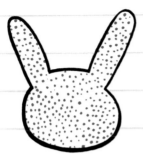

Make a lot
of dots to
fill an area
with a tone.

Try stippling here!

Short Hatching

Hatching, but fun-sized!
Change the directions of
the lines to bring it to life.

Try short hatching here!

Waves

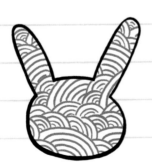 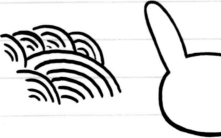

Draw a little rainbow of
semicircles in your open
space and repeat.

Try your own waves here!

DraWing WarMupS

Drawing is sort of like a sport—it's best to get warmed up before you do it, especially if you're not sure where to begin with your doodle. These simple exercises will loosen up your hand and free your mind.

Try TheSe + Have fun!

Try drawing with your eyes closed:

A Tiger

A House

A Flower

A Self-Portrait

Try drawing with your non-dominant hand:

A Dinosaur

A Dog

Your Favorite Film or TV Character

An Octopus

Fill in the Squiggles

Use these pre-drawn shapes as a starting point for your artwork. Turn these squiggles into whatever your imagination sees!

Here's an example of what you could turn your squiggle into!

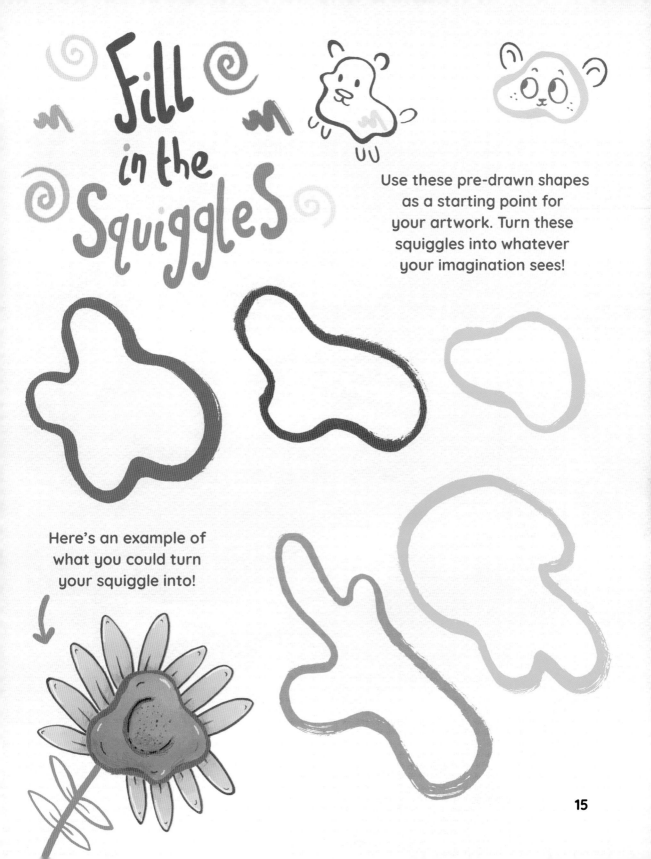

you can doodle animal Friends

LET YOUR
CREATIVITY
RUN WILD
as you draw little
creatures with
big personality

Birds

There could be an entire book on these fabulously feathered friends. But let's start with two funky birds who will take your skills to new heights.

CHICKEN

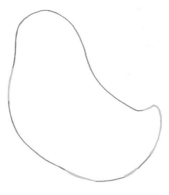

1.

Start with a bean-like shape.
The little tail feather has a point to it.

2.

Now it's time to
add some fluff.

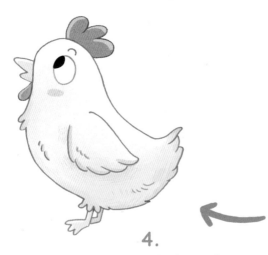

4.

We add the most chickeny features
here: A comb, a beak, and a wattle.
Now this hen is ready to squawk.

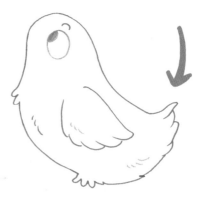

3.

Ca-caw! Draw the face
and a flappable wing.

TOUCAN

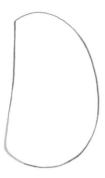

1.

Start with a bean shape.
The left side should be flatter
than the rounded right side.

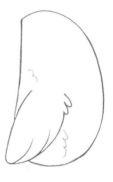

2.

Draw a wing and
some belly fluff.

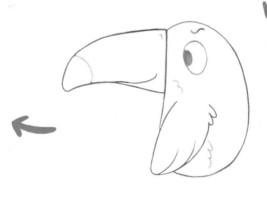

3.

Toucans have enormous,
banana-like beaks
to help them crack
open their snacks..

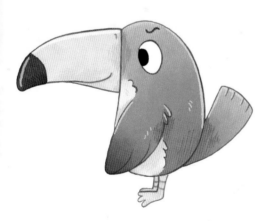

4.

Finish your toucan by
adding legs and a tail. Get
creative with your colors!

Tiny Critters!

Whether you find them scary or adorable, bugs are full of personality!

BUTTERFLY

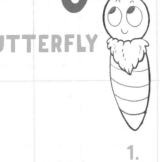

1.

A butterfly's body is shaped like a peg. They also have what looks like a fluffy beard below their head.

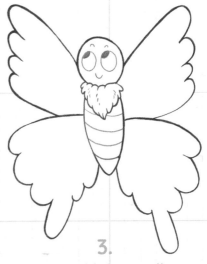

2.

The wings are the tricky part. Start with the lower ones.

3.

Then add the smaller upper wings.

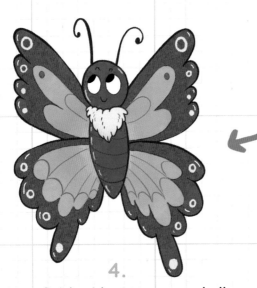

4.

Now finish with antennas and all the details inside the wings. Make blue wings or rainbow wings— whatever looks right to you.

LADYBUG

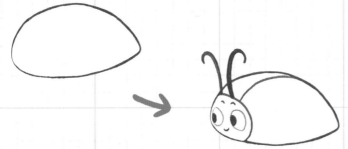

Ladybugs have beautiful markings
on top of their smooth shells. Don't
forget to draw in those little legs.

SNAIL

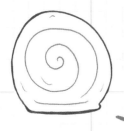

This snail shell looks
a little bit like a
cinnamon bun!

You have to love snails,
slime and all. They are very
resourceful and carry their
home right on their backs.

Chill Vibes

Aaaah...Take a deep breath and relax with a few amazing animals who love chilling in the water.

OTTER

1.

Start with the otter's sassy little face.

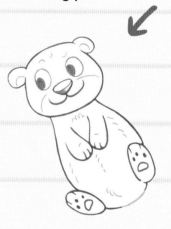

2.

Draw his body like the bottom of a bowling pin.

3.

Give that baby otter some furry paws. Otterly adorable.

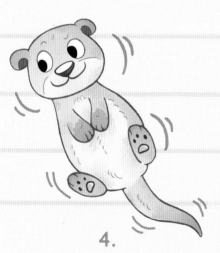

4.

Add a long tail and some wavy wiggle lines to show that he's moving in the water.

NARWHAL

1.
Start your narwhal
by drawing her
comma-shaped body.

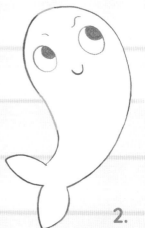

2.
Doodle some
fishy fins and a
feisty expression.

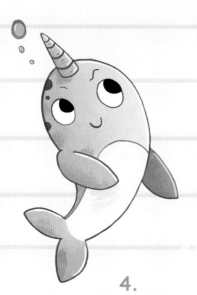

4.
Make your narwhal the unicorn
of the sea by adding a horn
and some dreamy bubbles.

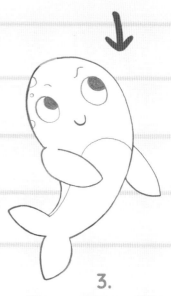

3.
Add the upper fins
and some circular
markings on the head.

Dino-Mite!

Get ready to roar and bring these prehistoric pals back from extinction.

STEGOSAURUS

1.
Begin with an almond-like shape.

2.
Give that almond body some legs.

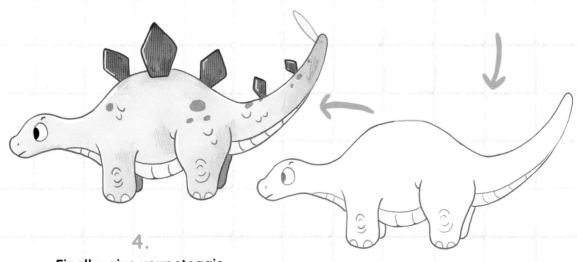

4.
Finally, give your steggie some diamond-shaped spikes and some color.

3.
Elongate the body with a neck, head, and tail at the other end.

T-REX

1.

Take your time drawing the tricky oblong body of your t-rex.

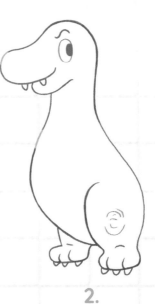

2.

Add the scary look and some powerful legs.

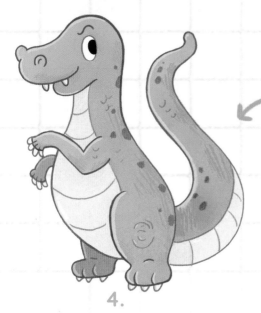

4.

One chunky tail later, you have a complete t-rex to color!

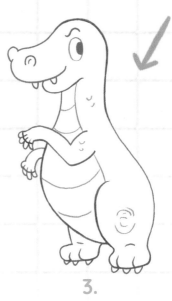

3.

No t-rex is complete without its tiny arms. So endearing.

Forest Friends

Get cozy at your drawing table and bring these cuddly woodland creatures to life, one line at a time.

FOX

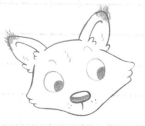

1.

Fox faces look kind of like a sideways diamond. Add some rounded triangle ears, and you're off to a good start.

2.

Draw a watchful, inquisitive face.

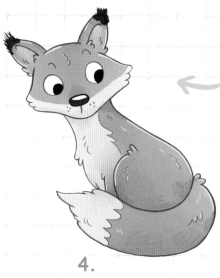

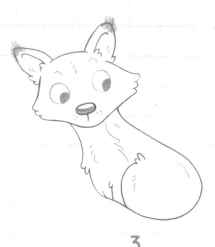

4.

Finish with a big puffy tail curled around the body.

3.

Make the body slinky and sleek.

HEDGEHOG

1.
Give this cheeky hedgehog a curved head with a nose and some oval-shaped ears.

2.
Draw a look of surprise with big eyes and a little brow.

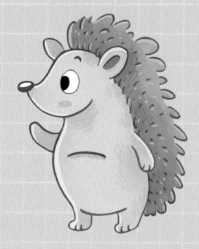

4.
Add a thick layer of quills to protect your hedgie as he waddles through the leaves.

3.
Give your hedgehog a round belly and some arms and legs.

DEER

1.
Start your deer with a rounded square shape for the body. Add four stubby legs, a neck, and a fluffy chest.

2.
Time for the head. Be sure to include a bump where the big, boopable nose will be.

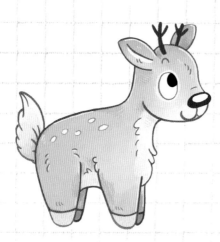

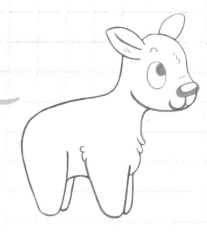

4.
Tiny antlers and a puffy tail are the finishing touches.

3.
Draw the doe-eyed features and ear details.

SQUIRREL

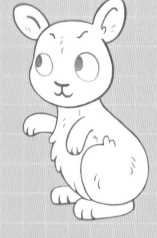

1.
It's no mistake that this squirrel's head is shaped like its favorite food, an acorn.

2.
Now draw this tree ninja's furry form so it can leap from branch to branch.

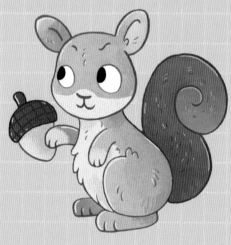

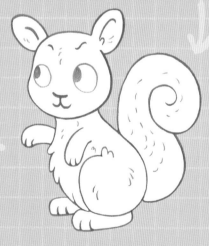

4.
This squirrel gets a free dinner! Put an acorn in its hand to complete the drawing.

3.
Don't forget to add a swirly, swishy tail. Make it look soft enough to touch!

Sleepy Self-care

Relax and rest easy as you draw these snoozing animal friends who appreciate the health benefits of a good nap.

BEAR

1.

This bear loves its curves. Draw its belly nice and round and add a pointy head and some little feet. NOTE: The blue lines, as you remember, get erased in the next step.

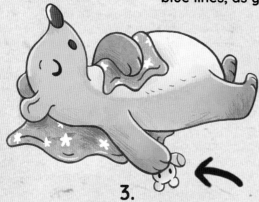

3.

Finish your drawing with fun details—like a cozy blanket and a teddy bear. Sweet dreams!

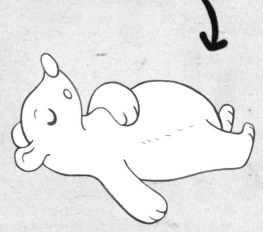

2.

Add some ears, a cute snoot, and some floppy arms.

Most animals (aside from snakes, guinea pigs, rabbits, and a few others) snooze with their eyes closed. To draw closed eyes, draw a U shape or an upside-down U shape (for smiling, closed eyes).

SLOTH

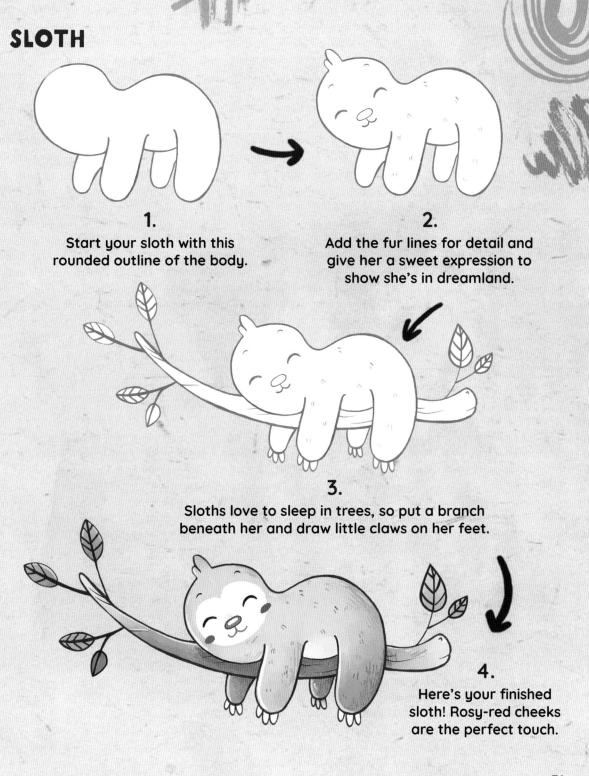

1.

Start your sloth with this rounded outline of the body.

2.

Add the fur lines for detail and give her a sweet expression to show she's in dreamland.

3.

Sloths love to sleep in trees, so put a branch beneath her and draw little claws on her feet.

4.

Here's your finished sloth! Rosy-red cheeks are the perfect touch.

Purrfect Pets

Pets are the best. Whether you're a cat or a dog person—or both—we can all agree that their cuteness is part of their appeal.

CAT

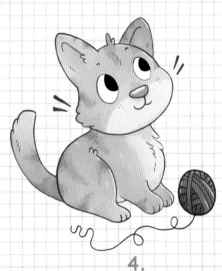

1.

Draw a round head with a little divot for the cheek.

2.

Next, add the pointy ears and a sweet little face. Who are they trying to fool with that angelic expression?

4.

Whiskers will do just fine. And of course a tail is necessary for balance. Wait! That's why they're looking up sweetly: They unraveled your knitting yarn again!

3.

Add a rounded body with teenie paws to catch mice and bat at some yarn.

DOG

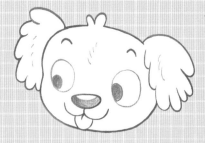

1.

For a pawsome start to your pup, make a bean-shaped head with a slight dent on the left side.

2.

Make some fluffy ears and a friendly face with a slobbering tongue hanging out. Watch out for drool!

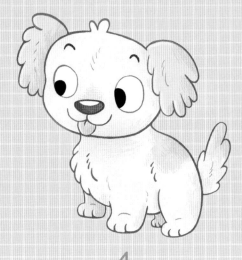

4.

Add the final two feet and a mega-fluffy tail to wag. This guy's cute. No bones about it.

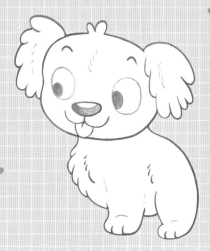

3.

Now you can draw the body with its curved shapes and chunky paws.

MORE PETS!

Cats and dogs may be the most popular
pets, but these lovable creatures can
also be great to come home to.

RABBIT

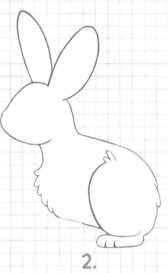

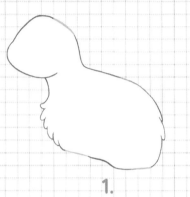

1.

Rabbits begin with a body shape that's
a soft, tilted rectangle that gives way
to a squarish head. You're on your
way to sketching somebunny special!

2.

Time to add the most rabbity
parts: Those giant ears and
that thumping back leg.

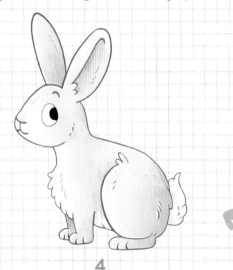

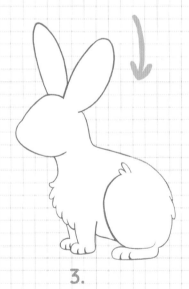

4.

With an adorable face that says,
love me, and a fluff-tacular tail,
your rabbit is ready to bounce.

3.

Now for the speedy
front legs.

PARROT

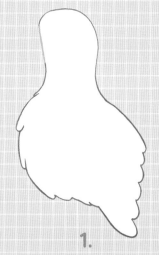

1.

Make a tall figure shaped almost like a vase with bumpy edges for plumage.

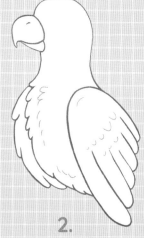

2.

Add some wondrous wings and a beak so your parrot can ask for crackers again and again. And again.

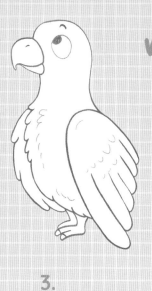

3.

Now add the face and feet.

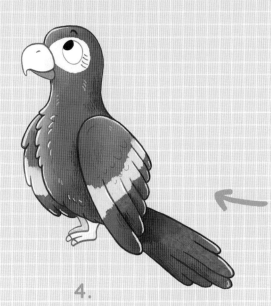

4.

Tah-dah! This beautifully colorful squawker is ready to soar!

Hats on Cats

You can use fun accessories and fashion flare to bring out the personalities of your animal drawings. Pop a hat on your cat, for example, and see what a difference it makes! Then try another one just for funsies.

Check out the headwear on the opposite page. Pick your favorites and give the cats below a quick makeover.

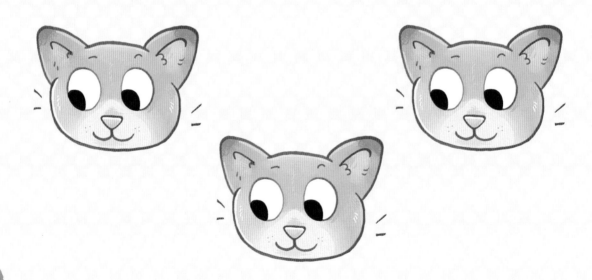

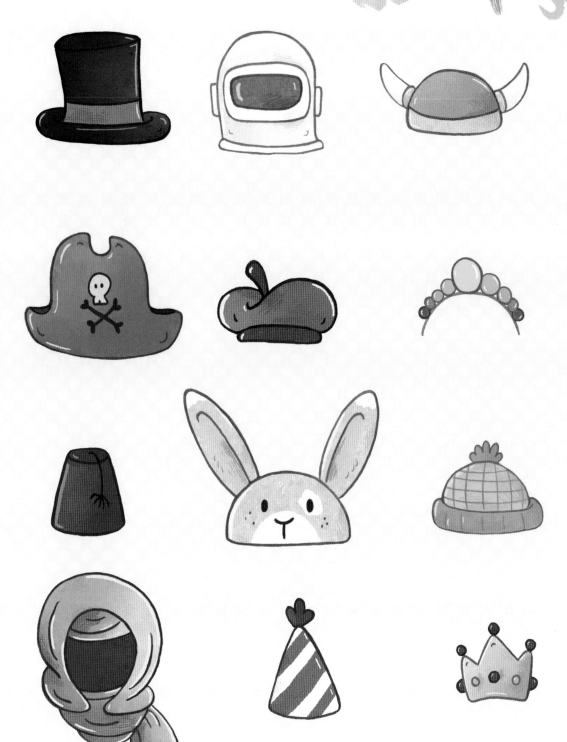

Cute Animal Faces

Have you ever wanted to draw, but you didn't know what to draw? All artists feel that way sometimes, and it's frustrating.

When you're short on ideas, start with a simple shape. Most cute faces begin with some form of a circle, so draw a circle and fire up your imagination from there.

Tired of circle faces? Try a chonky square and see if you can turn it into an object or a smiling animal face. What about ovals and hexagons? Don't hesitate to think outside the circle.

The Power of a Circle

Breaking drawings into simple, familiar shapes can help artists at any stage of their journey. This is one of many ways to sketch yourself out of a slump.

Here are some animal faces I drew from a circle. Think of the animals you love most and sketch them to life. Give them some of the expressions below or invent your own.

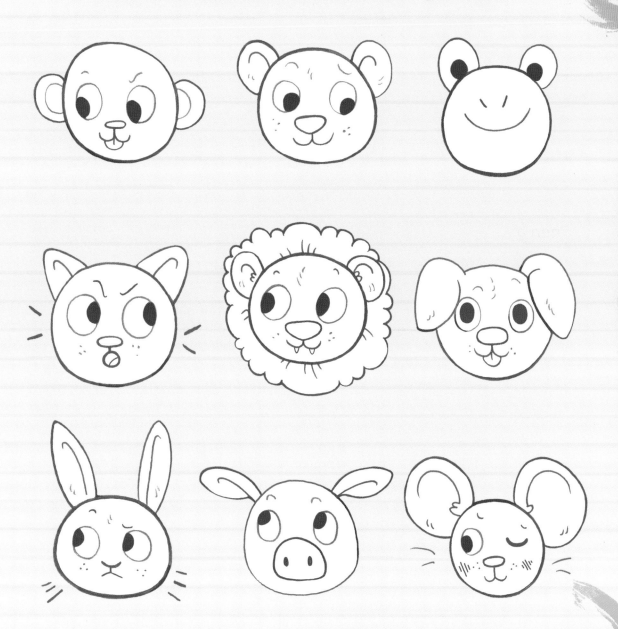

Safari Scribbles

Welcome to the jungle! Grab a vine, swing on a trunk, and doodle some adorable animals.

ELEPHANT

1.

This elephant has a circle shape for its head.

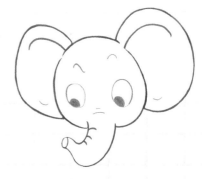

2.

Add the ginormous ears, the eyes, and the tube-shaped trunk that curls at the end.

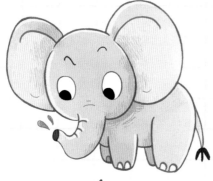

4.

Add a splash of water and a tail, and this little guy will stampede his way into your heart.

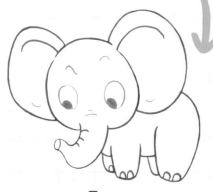

3.

Next, make the elephant's body surprisingly small to give your drawing a power boost of cuteness.

MONKEY

 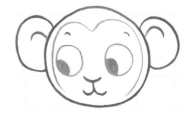

1.

Don't monkey around too much. Get serious and draw a circle for the monkey's head.

2.

Add some big ol' ears and a cute-as-a-button face.

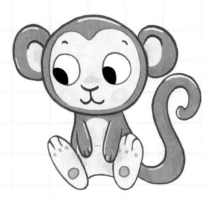 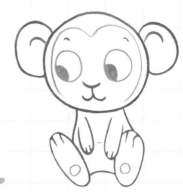

4.

Add that curly tail and you'll have everyone going bananas over your finished monkey.

3.

This sweet little chimp is sitting in a relaxed pose, just like your favorite teddy bear. Sketch out the body, paws and all.

GIRAFFE

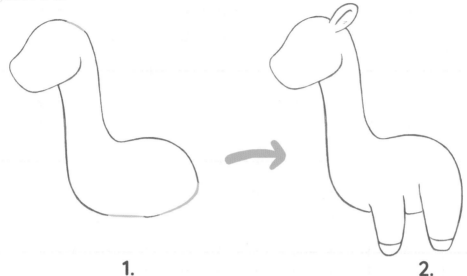

1.

Start your giraffe with its body and its looong neck.

2.

Next, draw the first ear and the front two legs.

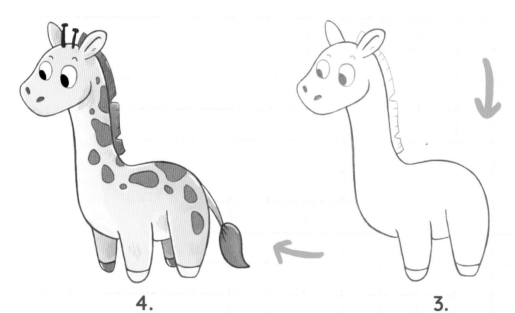

4.

Add two horns, back legs, and a tail that looks like a paintbrush, and you're just about finished. Don't forget the spots and a dash of color!

3.

Add a second ear, then doodle the face and hairbrush-style mane.

SNAKE

1.
A snake's slinky head looks like a backwards comma.

2.
Add a rubbery ring shape beneath the head to build out the body.

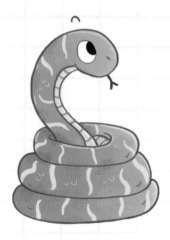
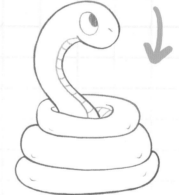

4.
Finish with a forked tongue and a funky pattern. *Hiss!*

3.
Continue by drawing two larger rings below the first one so your snake can coil up like it wants to. Then add a striped belly and an eye and nostril. A floating eyebrow is super fun here.

Surf's Up!

Let's take a deep dive into our creativity and doodle the friendliest sea creatures on Earth.

REMEMBER: Blue lines get erased in later steps. You already knew that? You're a whiz!

HAMMERHEAD SHARK

1.

This hammerhead's body looks like a pizza slice heaped with cheese.

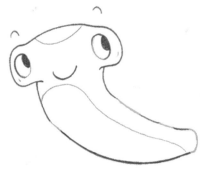

2.

Give this shark a face with eyes far apart, and make a curved line to show his belly.

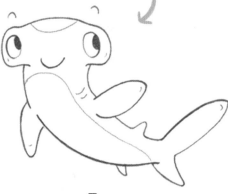

Hammerheads are great at DIY! They always have a tool ready.

4.

Finish by adding some color to your jawsome fish!

3.

Now you can add his fins.

Don't get crabby!
If you're feeling angry, grab
some paper and doodle
your frustrations away.

CRAB

1.

Start with a body shaped
like a walnut.

2.

Now draw some claws that could
crack any nut! The circles on the
arms are joints, but don't they
kind of look like bracelets?

I'm made
of strong
stuff, just
like you.

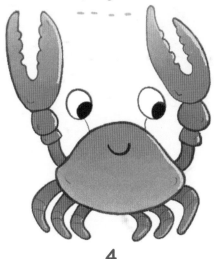

4.

All you need is a pinch of color
and your crab is complete!

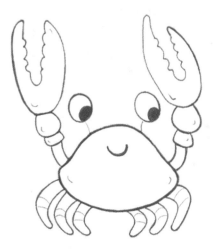

3.

To scuttle sideways, this crab will
need some legs. Six to be precise.
And it would be clawful not to add
some googly eyes and a smile.

MORE FISHY FRIENDS!

ANGLERFISH

2.
Add the anglerfish's best features so they're photo-ready. You know they're experts with a flash!

Go with the glow

1.
Start with a sideways deflated balloon shape. The round end of the balloon needs a little bump for the underbite.

3.
Don't forget that lantern above their head. Now you can color this adorably unique fish any shade you want.

CLOWNFISH

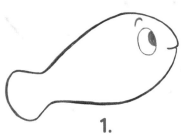

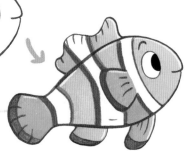

1.
Draw a shape that looks like a well-known fish cracker. Add a face.

2.
Now add the fins. The one at the top is wavy.

3.
This cute little clown is almost ready to tell jokes. It just needs its signature markings and colors.

UMBRELLA OCTOPUS

1.
Start by drawing an upside down tulip, or a little ghost.

2.
Give them the most adorable face and two funny horns.

3.
Remember you can always stand under this umbrella. . . octopus.

PUFFERFISH

1.
A surprised pufferfish is very round, like this circle.

2.
Next, draw the spikes and fins. The spikes can be pointy or round, depending on your preference. I like rounded spikes.

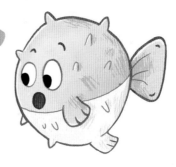

3.
Add a shocked or grumpy face like someone woke her up, and you've finished drawing this little ball of cuteness.

47

How to Draw Allan

Doodle some sweet and silly animal characters like this one, then invent your own!

There are no other dogs like Allan. He's everyone's favorite dancing dude and he can turn a ho-hum gathering into an all-out party.

1.
Start with a circle.

2.
Next, draw his cool, confident face.

6.
A funky disco ball and some headphones are in order. Now it's time to boogie.

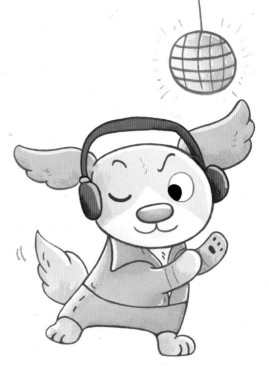

3.

Help Allan get ready
for the club by adding
paws to clap with and
a big open collar with
a hint of chest fur.

What song
motivates you to
take on the day?

4.

Add his legs and
his dancing feet.

Allan
Fever!
↓

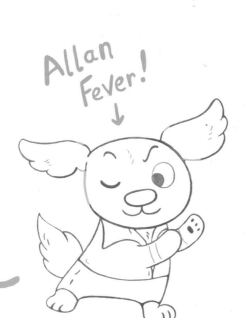

5.

Those ears and that
tail will be flying as
he does his thang.

How to Draw

Dot

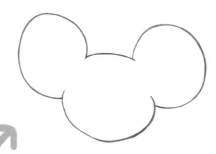

Dot is *strong* and *thriving!* They love every inch of who they are and so should you.

2.

Draw two large circles above that head and make Dot's ears.

1.

Dot has a circular head with a gentle point at the bottom for the chin.

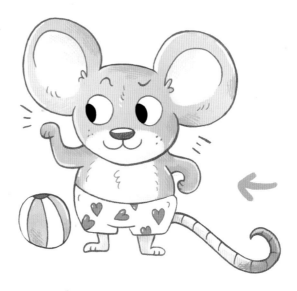

6.

Draw Dot's long mouse tail and a beach ball for fun. This mouse is ready to hit the beach.

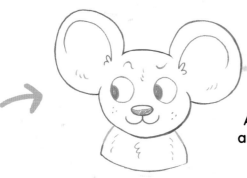

3.

Add a bold smile
and a fluffy torso.

Write three things you
love about yourself.

(Dot can name about a thousand things.)

1. _____

2. _____

3. _____

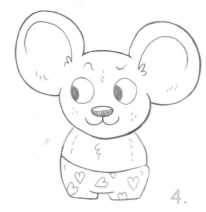

4.

Time to add
Dot's funky,
heart-patterned
swim shorts.

Kapow!

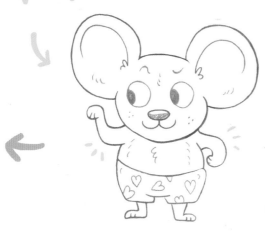

5.

Two tickets to the
gun show, please.
Add Dot's flexing
arms and little feet.

How to Draw

Aaron

Aaron the axolotl is smooth as a salamander can be. He's always got a ukulele in his hands, and he brings good vibes wherever he goes.

1.
Aaron begins with a humble circle for his head.

2.
Next, you can add the iconic axolotl gills.

Aaron's mom used to tell him: Axolotl questions and you'll get a lot of answers.

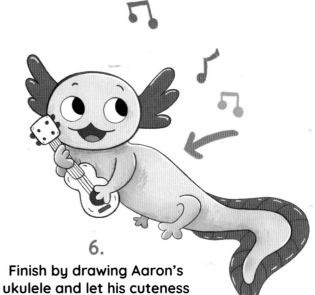

6.
Finish by drawing Aaron's ukulele and let his cuteness and his talent shine.

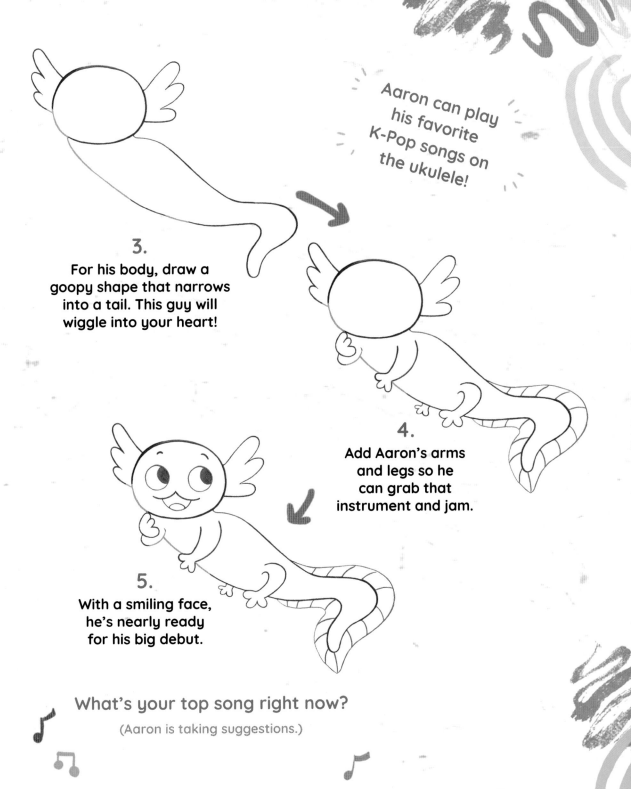

Aaron can play his favorite K-Pop songs on the ukulele!

3.
For his body, draw a goopy shape that narrows into a tail. This guy will wiggle into your heart!

4.
Add Aaron's arms and legs so he can grab that instrument and jam.

5.
With a smiling face, he's nearly ready for his big debut.

What's your top song right now?

(Aaron is taking suggestions.)

How to Draw Herman

Herman is a *happy* chap. He always has a smile on his face and feels sunny inside.

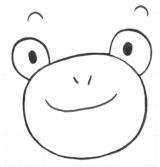

2.
Draw two small circles above the main circle. These are Herman's eyes. Don't forget to add nostrils and a smile.

1.
Like many of the animals in this book, we start with a simple circle.

What makes you happy?
(Herman loves board games.)

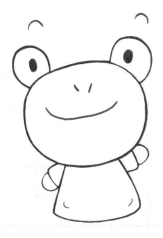

Swatch Time!
What colors make
you happy?
Scribble them
into these boxes.

3.

Add a torso
and two more
small circles
for his hands.

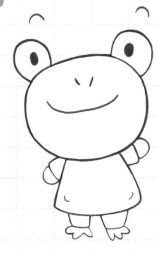

4.

Herman needs his
frog legs. Each
foot is shaped like
half of a star.

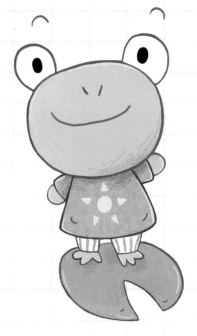

5.

Don't "froget" his lily
pad and his sunny
t-shirt design.

Hello Herman!

How to Draw

Samuel

Samuel is feeling blue. He's having one of those days where nothing seems to be going right.

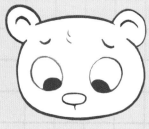

2.
Make sure to add the adorable worried face. Poor li'l cub!

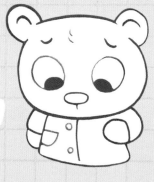

3.
Next, add a torso. Make sure it's smaller than the head because big heads and small bodies = cute!

1.
Start by drawing Samuel's round head and adding two round ears on top like this.

We all have days when we feel sad. What cheers you up?

(Samuel takes a bubble bath after a bad day.)

--

Swatch Time!

What colors would you use to represent feeling sad? Scribble them into the boxes at right.

5.

Place an umbrella in Samuel's hands to help him weather this passing storm. Add any pattern you like!

4.

Finish Samel's lower body by adding two little legs and feet. Make two little claw marks on his bare feet. Or is it bear feet?

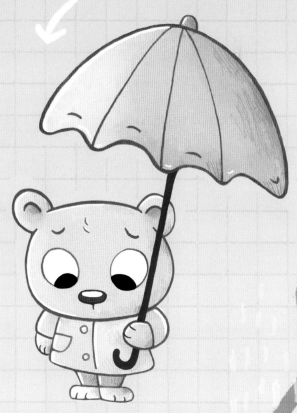

6.

You're all done now. Just add a splash of color!

How to Draw

Hamza

Cowabunga dudes! Hamza is a bit of an *anxious* guy, but his taste for adventure wins out every time. Watch him try skateboarding!

2.

Next, add a soft, round body below it.

1.

Draw Hamza's head like you would a squishy or melted marshmallow.

6.

For the finishing touches, draw his whiskers, his skateboard, and some motion lines behind his skateboard for fun. Watch out, Hamza!

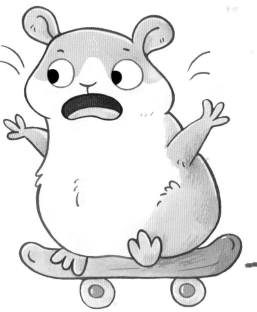

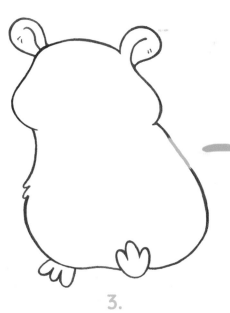

3.

Add little peekaboo ears
and animated feet.

*Life is more
exciting when you
try new things!*

4.

Next up: This
hamster needs his
arms to catch him
in case he falls!

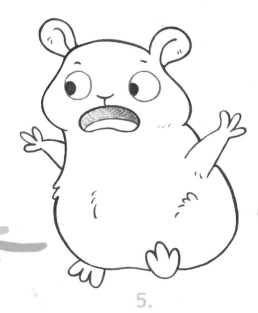

5.

Poor Hamza didn't see where he was going
until now, and he's about to crash. Draw
those big eyes and that worried expression.

How to Draw

José

José is having a bad day. He can't find his crown anywhere (little does he know he already put it on his head). Silly guy.

What puts you in a bad mood?

(José hates it when he misses his bus.)

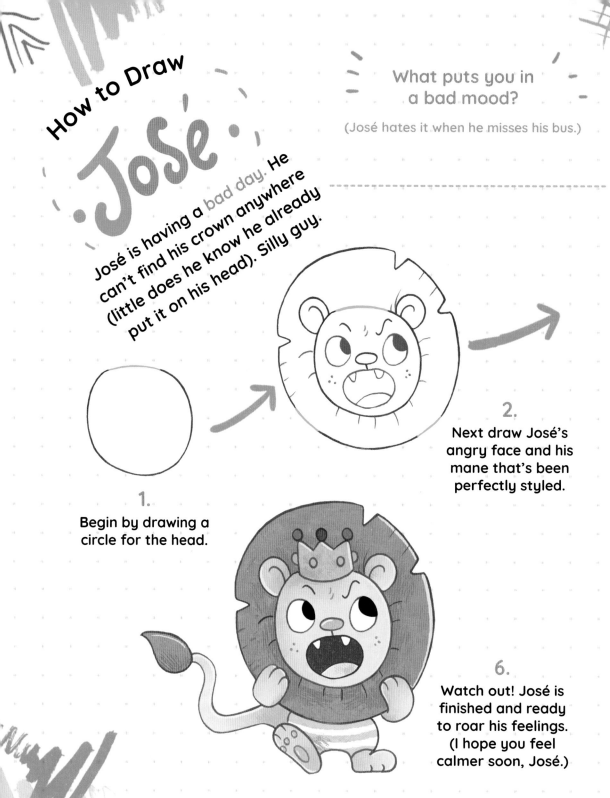

1.
Begin by drawing a circle for the head.

2.
Next draw José's angry face and his mane that's been perfectly styled.

6.
Watch out! José is finished and ready to roar his feelings. (I hope you feel calmer soon, José.)

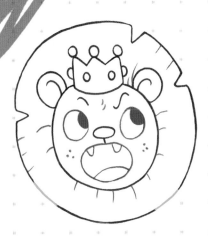

3.

This lion king wouldn't be complete without his crown.

Swatch Time!

What color feels most angry to you? Scribble it in the swatch box at right. Let those feelings out.

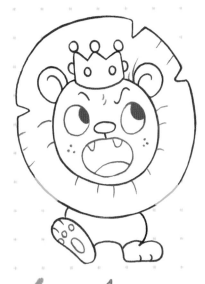

4.

Add a body and two legs for stomping around loudly.

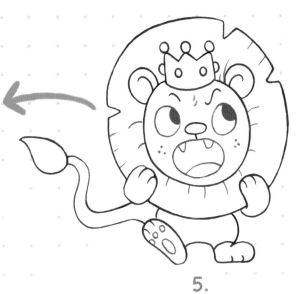

5.

Next, add arms and a tail.

How to Draw Oswald

Oswald is a bookworm. He always has his beak in a book. Oh, and he eats worms.

2.
Give Oswald those stellar brows.

Brows on Fleek!

1.
Start with a shape that looks like a dough ball.

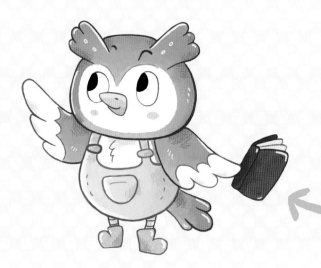

6.
Now it's time to give Oswald his favorite book and a pop of color. Hello, Oswald!

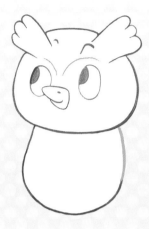

3.

Add his rounded torso.

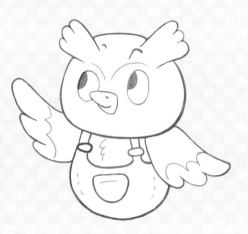

4.

This owl wears overalls. He has lots of pockets for storing his library card and bookmarks. Draw his wings for holding his books.

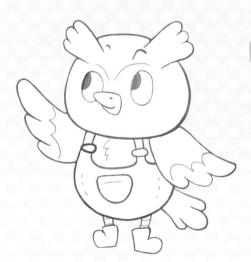

5.

Doodle some legs and a pair of little boots.

How to Draw

Rosa

Rosa is **strong**. She takes the yays and grrs of her life in stride and is ready to take on the world!

2.

Once you have Rosa's head complete, add her tall bunny ears.

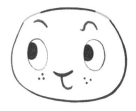

1.

Rosa's head is like a teardrop shape without a point at the top. Her face is determined and proud.

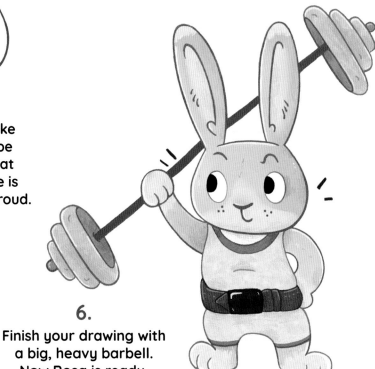

6.

Finish your drawing with a big, heavy barbell. Now Rosa is ready.

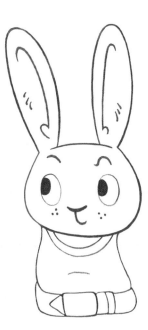

3.
Add Rosa's torso and belt so she can work those abs.

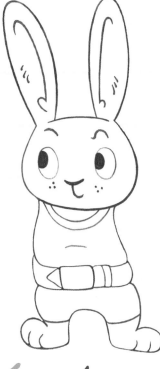

4.
In her free time, she loves dancing to hip hop. So draw two mighty legs for hopping.

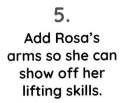

5.
Add Rosa's arms so she can show off her lifting skills.

Swatch Time!
What color is uplifting to you? Scribble it here.

How to Draw

Roscoe

Roscoe is HUGRY! All he wants to do is snack on tasty treats to satisfy his sweet tooth. We've all been there, Roscoe.

2.
Pop two triangle ears on top of that head and add a look of focused excitement.

1.
Roscoe has a football-shaped head with tufts at the sides.

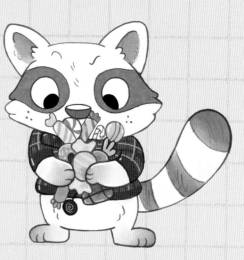

6.
Give him a bushy raccoon tail and a pop of color. Happy snacking, Roscoe!

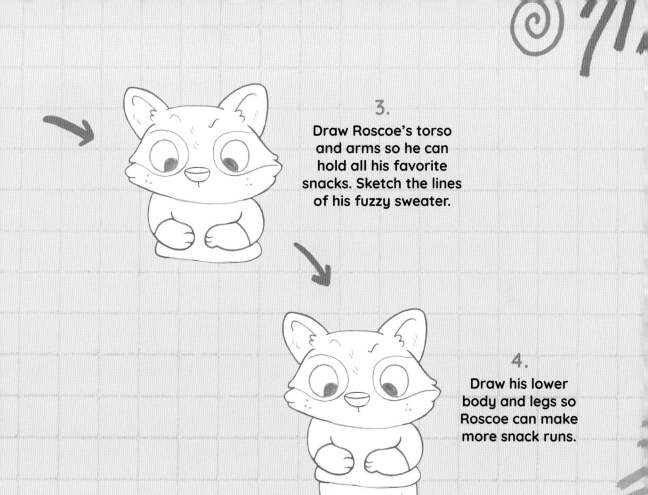

3.
Draw Roscoe's torso and arms so he can hold all his favorite snacks. Sketch the lines of his fuzzy sweater.

4.
Draw his lower body and legs so Roscoe can make more snack runs.

5.
Now you can draw your favorite treats in Roscoe's hands. Nom!

How to Draw

Free your mind as you vibe out with this meditative cat named Zen. She loves teaching others how to quiet their minds to a gentle purr.

List a few things that help you relax:

- - - - - - - - - - - - - - - - - -

- - - - - - - - - - - - - - - - - -

2.

Add the sweet winking face and some furry details.

1.

Let's start with a classic cat head shape: A circle with two triangle ears.

6.

The sound of raindrops is extra calming. Add some if you please. And then give Zen some bright yoga gear and a pop of color.

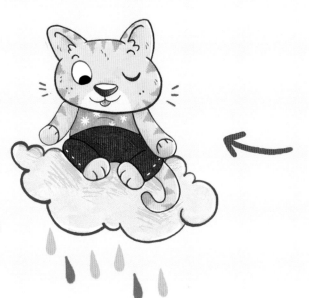

FEED YOUR SOUL
Drawing can calm your mind and make you feel good. So doodle away!

3.
Give Zen her arms so she can hold them out, paws up to the sky in gratitude.

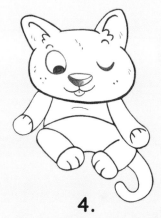

4.
Now exhale. It's time to add the legs and tail.

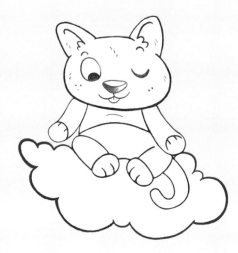

5.
Zen is so relaxed, she feels like she's floating on cloud nine! Draw that peaceful cloud below her.

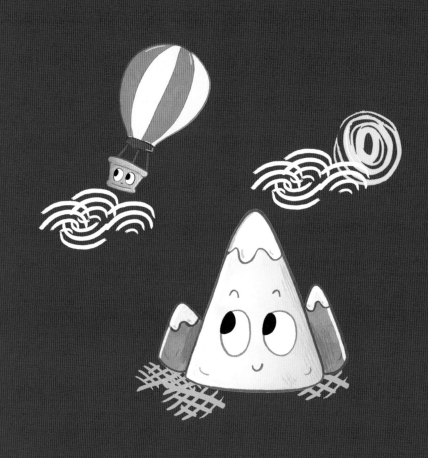

You can doodle a Great Big World

THE SKY'S THE LIMIT when it comes to drawing natural wonders and city sights.

Beep! Beep! I'm trying to draw over here! Celebrate the hustle and bustle of a city with these quick and easy doodles for busy artists.

COFFEE CUP

Nothing says V.I.P. like walking around with a pumpkin spice latte in hand.

TRAFFIC LIGHT

 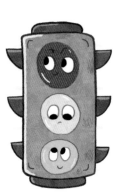

This traffic light is special, because it changes with your mood. Color in just the red light if you're feeling angry, the yellow if you're feeling meh, and the green if you're feeling great.

SKYSCRAPER

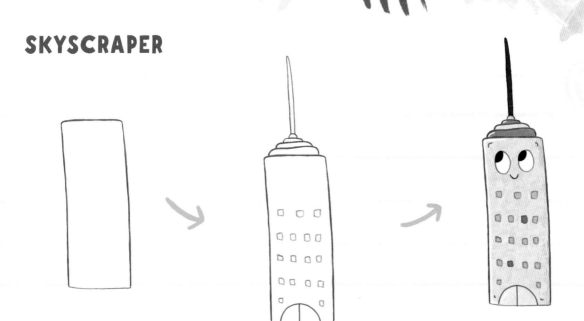

Start with this skyscraper, then add more to draw a whole city skyline!

TRAFFIC SIGNS

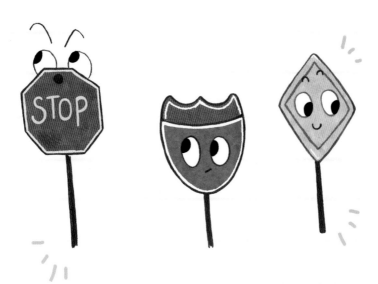

Doodle all three street signs and let them be your guide!

Out of Town

Let's go, jet-setters! Doodle your favorite vacation sights and memories so you can make your own travel scrapbook wherever you go.

I'm Coconuts for you!

PALM TREE

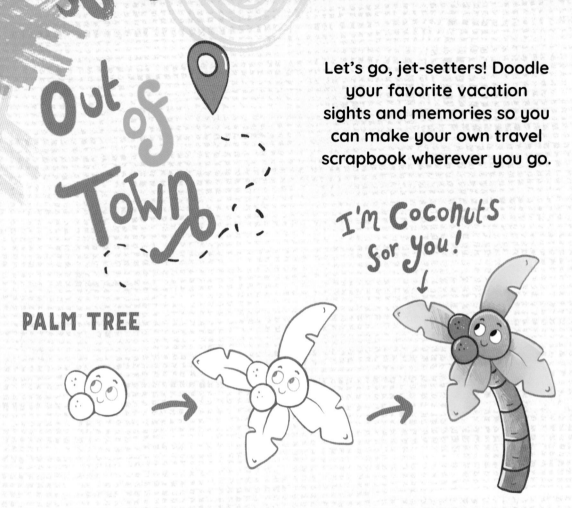

A little palm tree is the perfect way to illustrate your sunny vacation away.

CAMERA

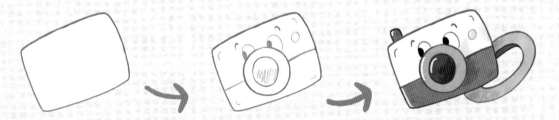

Maximize this camera's vintage cuteness with a bright color palette.

SUITCASE

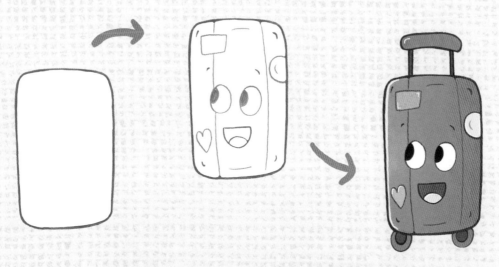

Nothing is more exciting than packing your suitcase to go somewhere fun. Add your own unique stickers to customize this doodle.

TENT

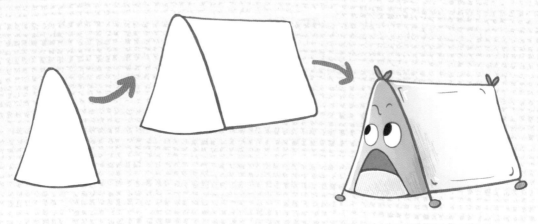

Time to draw a grumpy tent. If you think it's hard setting up a tent, imagine how the tent feels!

POSTCARD

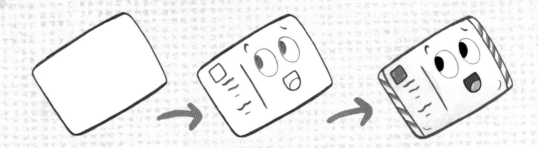

Doodle an adorable postcard and send it
to someone. Don't forget the stamp.

GLOBE

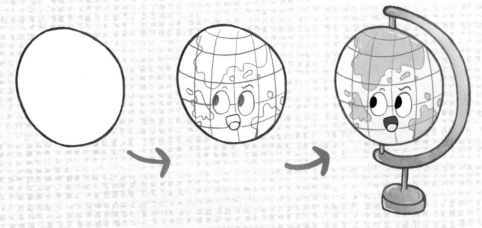

Doodle a globe while thinking about where
in the world you want to go next!

CHEEKY COCKTAIL

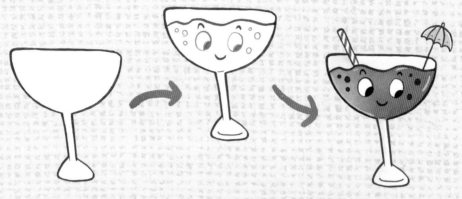

It doesn't feel like a vacay without
an umbrella in your drink!

SHELL

I'm not Shellfish!

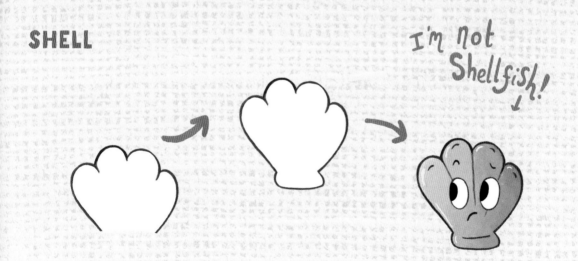

This unshellfish seashell can be doodled in just
a few easy steps. Make it as symmetrical as you
can or give it some quirky imperfections.

Nature's Cutest

Take in the fresh air and go for a walk in the countryside. Don't forget your sketchbook!

CLOUD

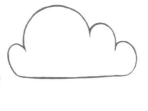

Start with the cloud's bottom line, then add the bumps on top. You can't go wrong!

MOUNTAIN

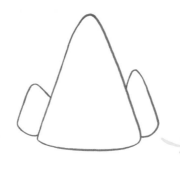

Ain't no mountain higher than your ability to learn and draw. Try your hand at doodling a friendly mountainscape.

HOT AIR BALLOON

 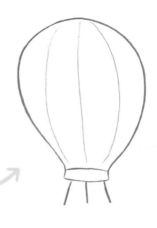 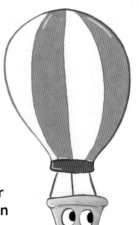

The best part about doodling a hot air balloon is that you can add any pattern or color palette when you're done.

LEAF

Leaf Me Alone ↓

 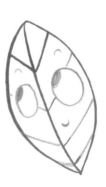

Leaves are easy and fun to draw. I chose a traditional leaf shape, but you can doodle any kind of leaf you want and even add some fall colors.

The Kawaii Forest

"Kawaii" is a Japanese term for cute and lovable, exactly what these doodles aim to be. Have fun designing your own adorable bouquet in a kawaii style.

1.

Choose from the three stems shown here and then add a flower head to create cool combos. I've plonked a flower onto a stem to give you an idea.

Lily

2.

Clover

3.

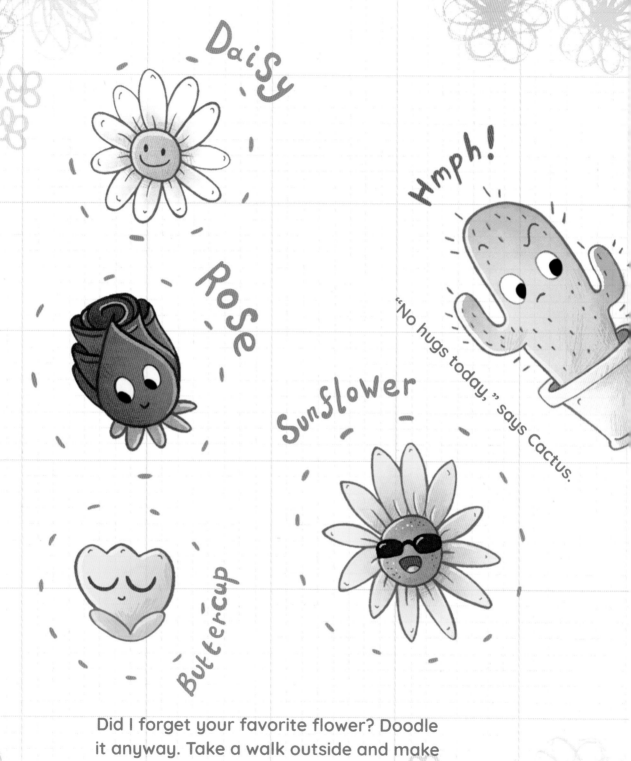

Daisy

Rose

Sunflower

Buttercup

Hmph!

"No hugs today," says Cactus.

Did I forget your favorite flower? Doodle
it anyway. Take a walk outside and make
a kawaii version of every flower you see!

go.go galaxy!

By using different mark-making techniques, you can draw a whole galaxy of cosmic planets.

A circle is the base shape for all of our planet doodles.

What a lovable bunch of oddballs!

Cloudy

Stripey

Swirly

Small or repeating patterns can make a big visual impact, and they're super relaxing to create. Take a deep breath and let your hand guide you. Use these patterns above for inspiration.

Add a ring like this one if you want. Then throw on some spots to make it more habitable for alien friends. Color it in!

Here are some cosmic variations that you can draw by starting with a circle.

Tiny triangle points surrounding a smiling circle make for a sweet little sun.

Draw a circle, but make it extra bumpy. Trail a hot flame behind it to make it a comet.

To make a crescent moon, draw a circle and then erase a chunk of it so it looks like someone took a bite out.

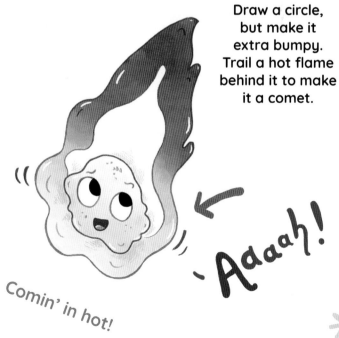

Comin' in hot!

Aaaah!

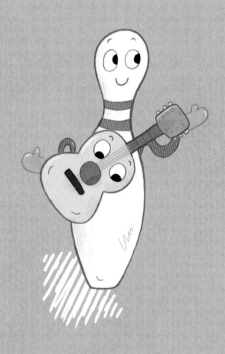

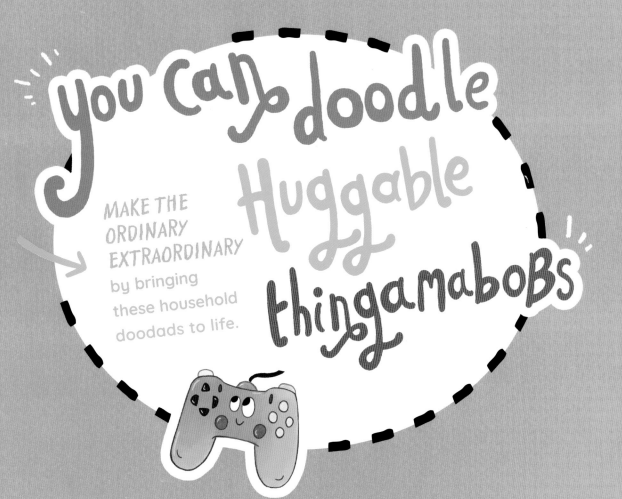

you can doodle

doodle

Huggable

thingamabobs

MAKE THE
ORDINARY
EXTRAORDINARY
by bringing
these household
doodads to life.

Game On!

Take pride in your favorite hobbies with these playful doodles showing all the ways you can live it up.

FOOTBALL

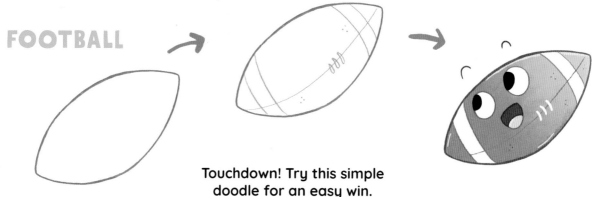

Touchdown! Try this simple doodle for an easy win.

PALETTE & PAINT BRUSH

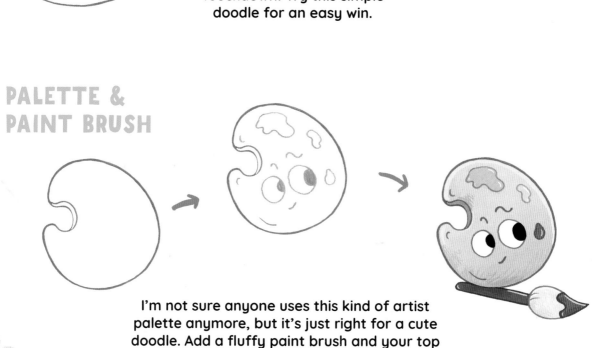

I'm not sure anyone uses this kind of artist palette anymore, but it's just right for a cute doodle. Add a fluffy paint brush and your top three colors and you're ready to Van Gogh!

GAMING CONTROLLER

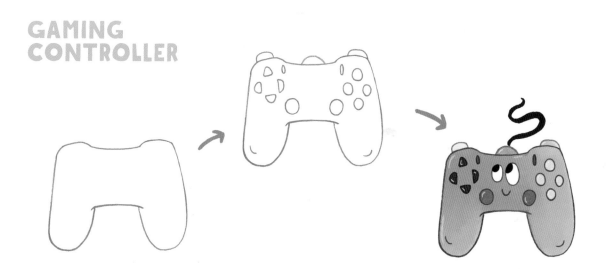

This doodle pushes all the right buttons.
Customize your drawing with the special
features that make your controller unique.

JIGSAW PIECE

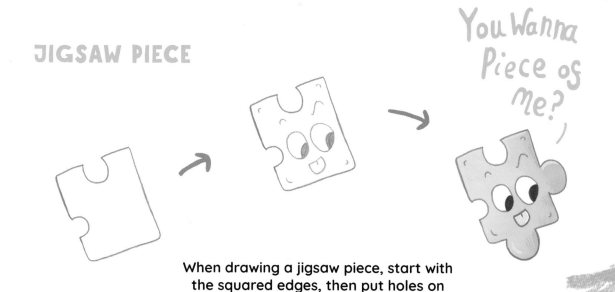

You Wanna Piece of me?

When drawing a jigsaw piece, start with
the squared edges, then put holes on
the edge like a piece of Swiss cheese.

KNITTING

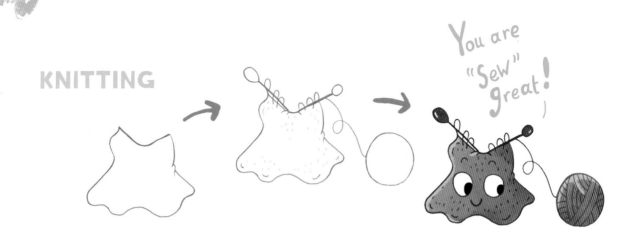

You are "Sew" great!

Crafting is a nifty skill for makers and clever creators like you! Draw this cute and snuggly pair of knitting needles.

CHESS PIECE

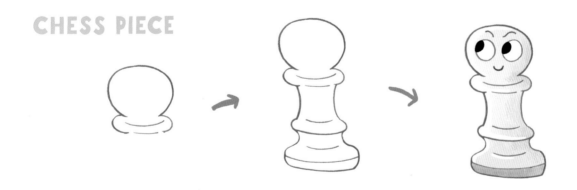

Checkmate! Take your time drawing the contours of this intricate game piece. Be strategic in how you draw it, just like a chess player would be.

GUITAR

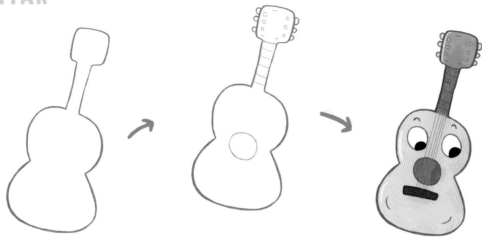

This goofy guitar hits all the right notes. Add his thin guitar strings using a fine-point pen or pencil.

PLANT

Unleash your green thumb as you draw this dreamy plant from pot to pointy leaves.

Cute thingamajigs

Can you think of some random household items that could be cutie-fied with a little doodling makeover? Now's the time to try.

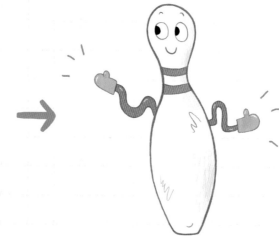

Turn this simple bowling pin. . .

. . . into a wiggly, arm-waving dude!

Or transform his buddy the bowling ball . . .

. . . into a hot-stepping, boot-wearing little guy!

Here are some things you can bring to life with your doodles. Add faces here or trace the objects onto a sketch pad and get weird and wild with them, adding all sorts of personality.

Use this whirling cloud of wacky arms and legs to turn an inanimate object into a walking, talking character.

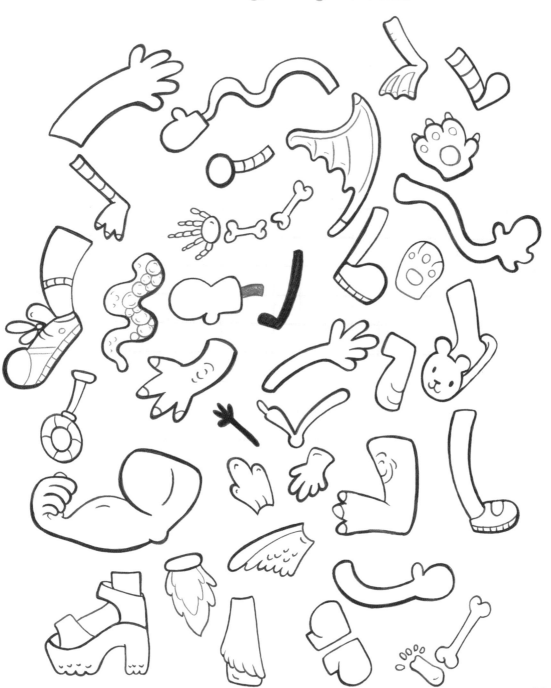

Work doesn't have to be serious or boring. Here are some stationary supplies you can doodle when you want to turn an office into a playground.

PENCIL

The classic yellow pencil is already an icon. Add a cute face and watch it draw lots of attention.

STAPLER

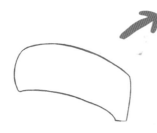
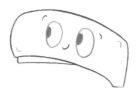
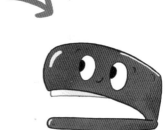

Once you draw this stapler with its simple shapes, you'll never want to remove it from the page.

CALCULATOR

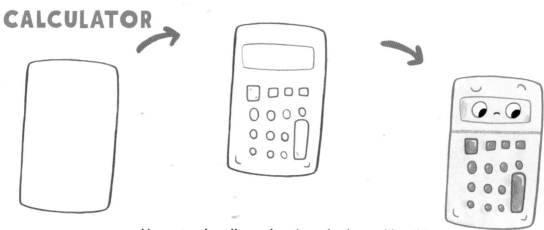

You can doodle a classic calculator like this
one by keeping it simple, or you can add extra
buttons to make it a science calculator!

DESK TOY

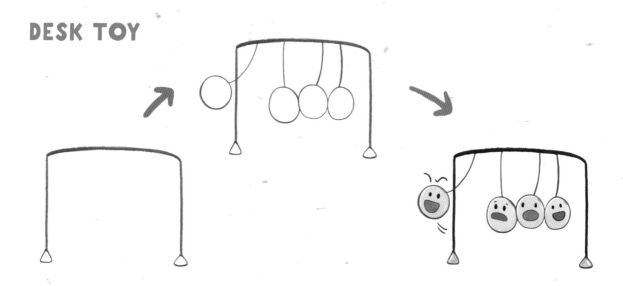

The original fidget toy, this retro desk toy is loads of fun,
especially when you add expressions to the clacking metal balls.

ENVELOPE

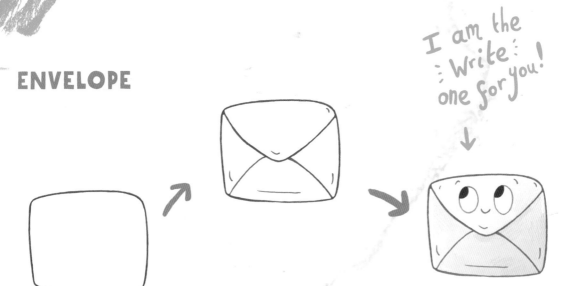

I am the Write one for you!

Got some letters to write? Sign, seal and deliver them in style with a little face!

CLOCK

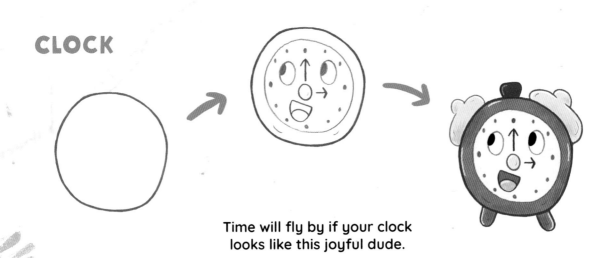

Time will fly by if your clock looks like this joyful dude.

PAPERCLIP

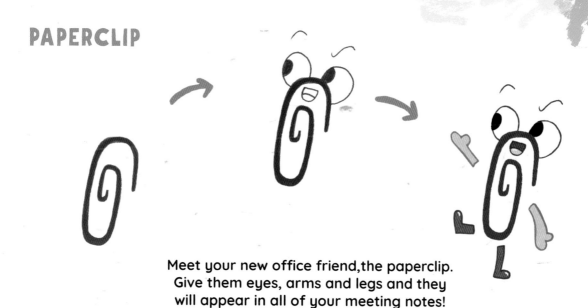

Meet your new office friend, the paperclip.
Give them eyes, arms and legs and they
will appear in all of your meeting notes!

TRIANGLE RULER

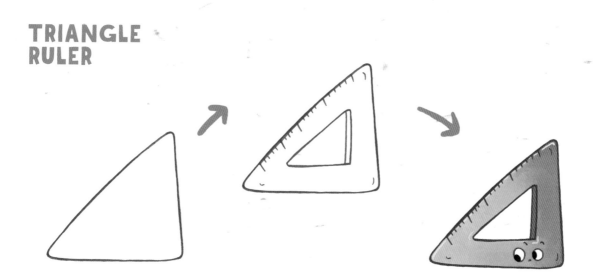

This unique ruler measures up to the
competition. Make sure to include a tiny face.

In the House

Look around the room. Do you see all the fun household objects you can doodle to life? Here are a few examples to get you started. Copy or trace them and make them your own!

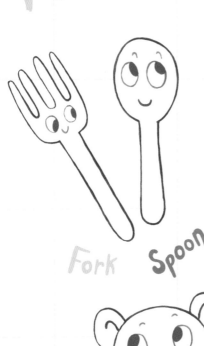

Fork Spoon

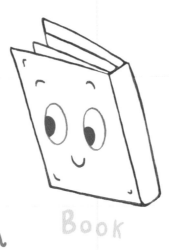

Book

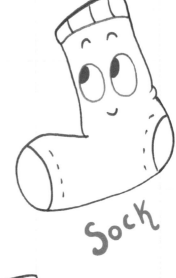

Sock

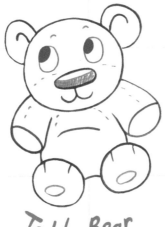

Teddy Bear

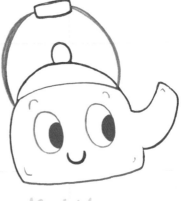

Kettle

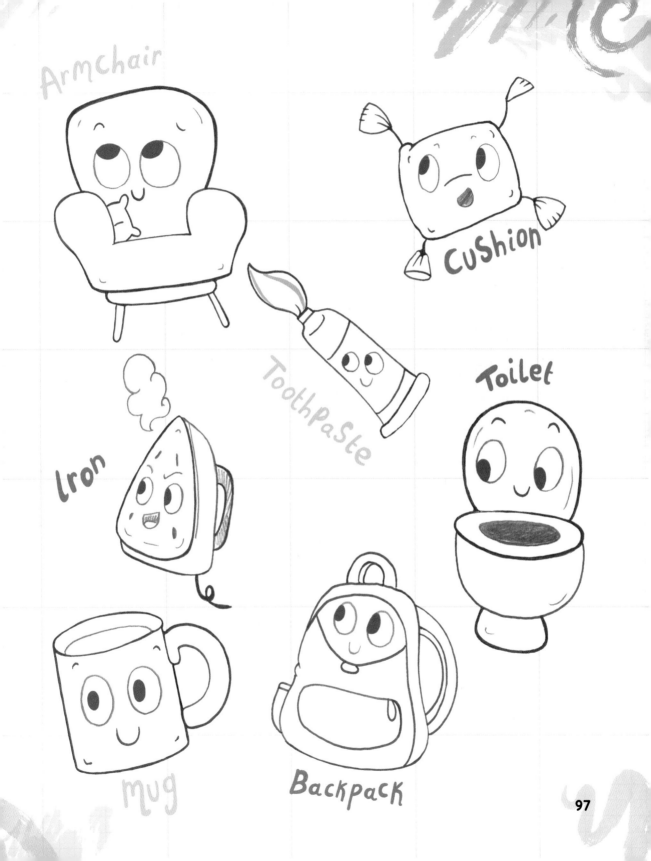

Armchair

CuShion

ToothPaSte

Iron

Toilet

Mug

Backpack

you can doodle Food!

FEED YOUR TALENT as you draw a smorgasbord of irresistibly adorable snacks, drinks, and foods.

Hello, Sugar!

Got a sweet tooth? Chomp on these clever doodles and fill up on fun as you doodle your cravings to life.

CUPCAKE

1.

Start your cupcake with a paper cup to bake it in.

2.

Add the swirly icing and a deliciously fun face. Erase the blue line in the next step!

3.

This is the cherry on top of a fabulous doodle.

BOBA TEA

 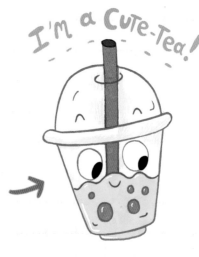

1.

For a refreshing boba tea, start with the cup.

2.

Add a face as big as the boba.

3.

Add a paper straw. You did it!

They say an apple a day keeps the doctor away . . .

But who could stay away from this a-peal-ing fella!

APPLE

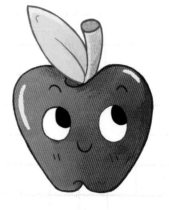

1.
Make a curvy
apple body.

2.
Draw the stem
and leaf.

3.
Fruity fun
complete.

ICE CREAM CONE

1.
Draw a melty circle
to begin your ice
cream cone doodle.

2.
Then add a sugar cone with
grid lines for texture. Or put
your ice cream in a cup!

3.
What's cooler than
cool? Sunglasses and
a genuine smile.

MORE FAST FOOD FROM THE DRIVE-THRU

No need to wait in line for a burger today,
You're about to build it yourself.

BURGER

2.
Add a corner of cheese that looks like a V and then doodle fluffy lettuce around it.

1.
Start at the top and make the bun.

3.
Finalize your burger with a patty, circular tomatoes, and a bottom bun. Time to add color!

I'm cheesy-going!

CROISSANT

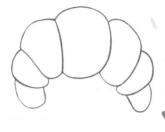

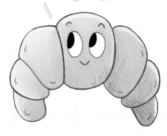

You're my secret ingredient!

1.

Fancy something from the bakery? Let's draw the center of a croissant like this.

2.

Repeat that same shape on both sides. The shapes should get smaller and smaller.

3.

Add a face, and bon appétit!

PIZZA

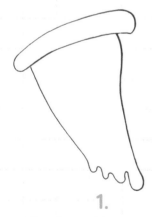

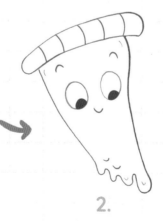

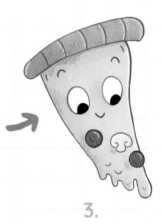

1.

Begin making a pizza slice by drawing a chunky triangle with cheese melting at the point. The crust looks like a bar on top.

2.

Make some lines on the crust and add a smiley face.

3.

Add your favorite toppings and admire your little slice of life!

You're Sweet!

These sweets and candies that look good enough to eat are easy to doodle in just a few steps.

HARD CANDY

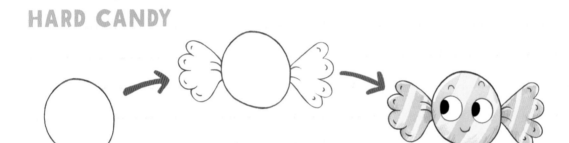

Beginning doodlers will love this easy-to-draw hard candy with striped wrapper.

DONUT

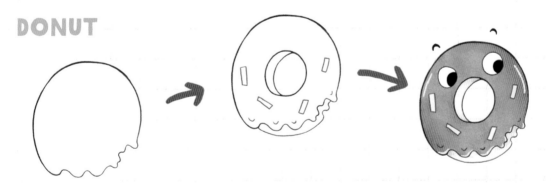

Okay, now let's get a bit trickier. This donut has a little nibble taken out of her. Instead of drawing a complete circle, add wavy frosting lines at the bottom and a spot where someone took a chomp.

PUMPKIN

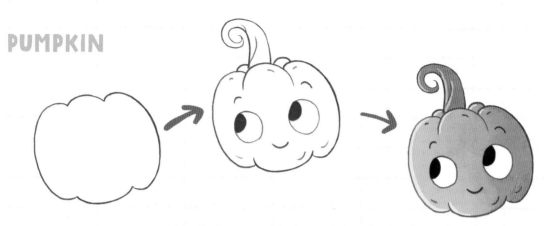

This little pumpkin is a cutie-pie. Well not yet. But someday maybe!

LOLLIPOP

This dapper little lollipop loves his bow tie. Have fun with the swirly pattern.

Finger Foods and Silly Fruit

When you have a snack attack, or need a little zest in your life, try doodling these handy foods that add some flavor to the day.

POPCORN

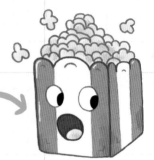

Geometry is a doodler's friend.
Think of this popcorn box as a cube
with only two sides showing.

HOT DOG

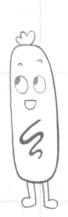

Do Diggity!

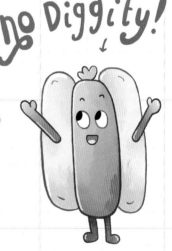

Give this ballpark frank some arms and legs so he
can help you cheer for your favorite sports team!

LEMON

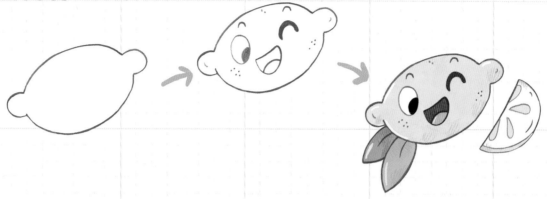

Get ready for a spritz of citrus fun.
When life gives you lemons, make some
lemonade and draw your heart out.

SUSHI

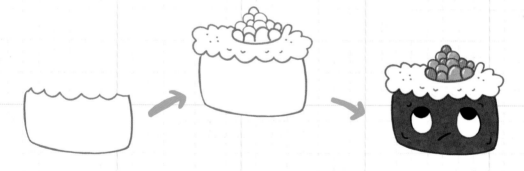

This sushi hits the spot. The only
question is. . . wasabi or no?

PEAPOD

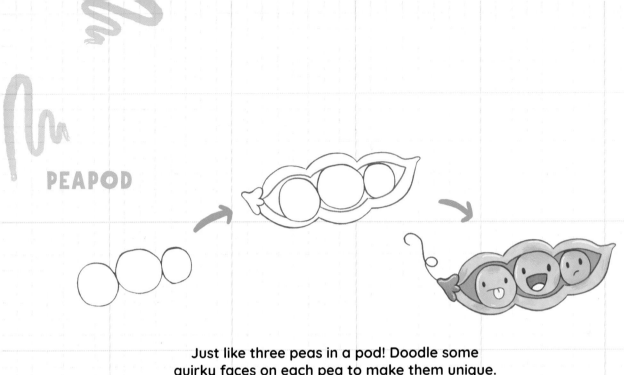

Just like three peas in a pod! Doodle some
quirky faces on each pea to make them unique.
Which one best reflects how you feel today?

CEREAL

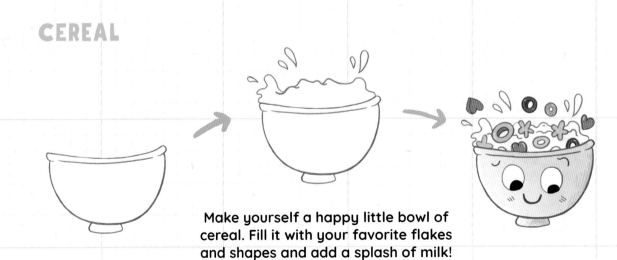

Make yourself a happy little bowl of
cereal. Fill it with your favorite flakes
and shapes and add a splash of milk!

TOAST

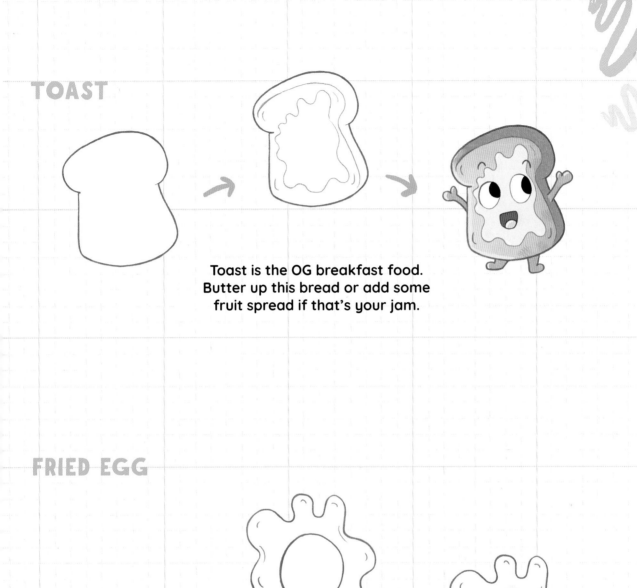

Toast is the OG breakfast food. Butter up this bread or add some fruit spread if that's your jam.

FRIED EGG

Sunny side-up is my favorite egg to draw. This little doodle is a healthy and creative start to your day.

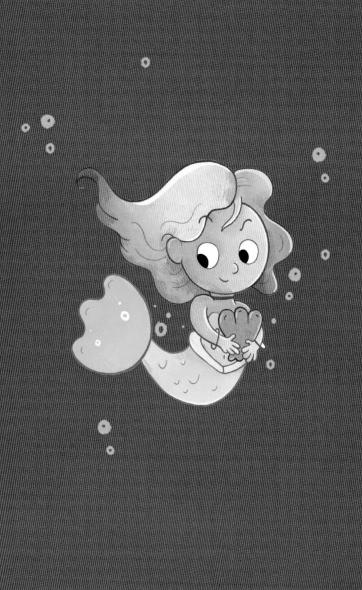

You Can doodle Magical Creatures!

BELIEVE IN YOUR OWN MAGIC as you create legendary beasts and mystical figures

Gnome Sweet Gnome

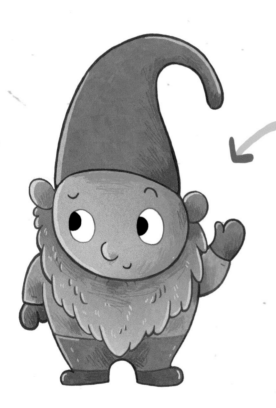

You are most likely to meet a gnome in the backyard, in a garden, or at a park. But chances are they'll find you first. Fun fact: These little treasure hunters love to hide stuff in their beards.

Things gnomes like to collect:

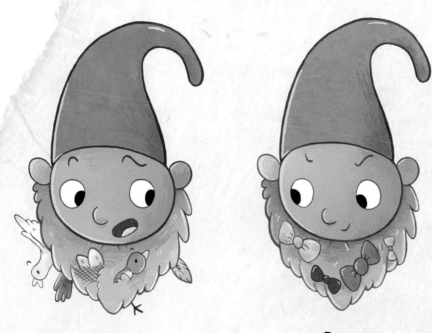

Birds

Bows

If you can't seem to find your keys or your treasure map, it's probably stashed somewhere in a gnome's beard.

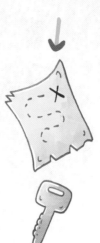

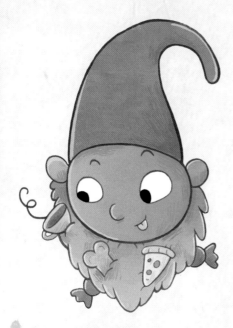

Food

Jewels

You're

Magic!

Let's go big on fantasy and bring a dangerously cute fire-breathing dragon to life right before our eyes.

2.
Draw a long shape below the head for the dragon's body.

1.
All good dragons start with a head. Watch out. This one can bite!

3.

Add a curved line for the dragon's cheek to break up the head and body and then add some fiery nostrils and a face.

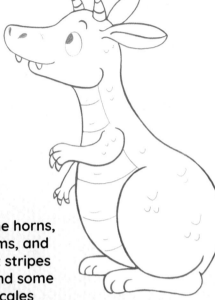

4.

Time to add the horns, ears, little arms, and big feet. Light stripes on the belly and some U-shaped scales bring this magical creature to life.

5.

The finishing touches are dragon wings and a powerful tail. You can also add a little puff of fire for fun!

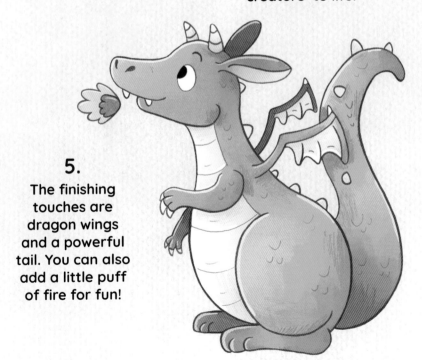

Spellbinding!

Grab your magic wand (i.e. pencil), a blank page, and get ready to conjure up the cutest little wizard and witch.

WIZARD

1.

Begin with a triangle hat that comes to a droopy point.

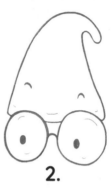

2.

Doodle two large circles below that hat for the wizard's glasses. Connect them with a curved line.

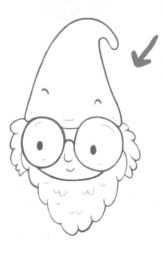

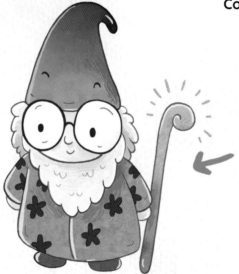

4.

Now draw the wizard's cape and the rest of his body. Give him a fun star print and a curved staff to channel his powers.

3.

Under the curved line, add a nose, a mouth, and a shaggy beard.

WITCH

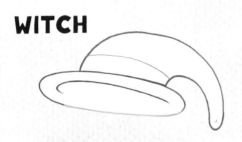

1.

Start with the witch's hat, just like you did with the wizard. This hat is wider and the point is much longer.

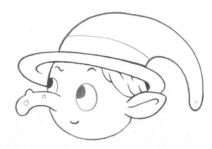

2.

Cackle to yourself as you add the witch's fabulously wicked features, beginning with that lovably crooked nose.

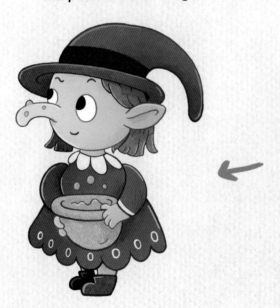

4.

Complete your witch by drawing the rest of her hair, legs, and boots, and—abracadabra— you've got yourself a witch.

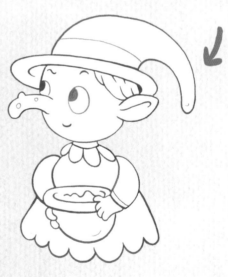

3.

Draw her body as she clutches her cauldron. She's ready to teach potion class now.

Holiday Heroes

These mythical heroes deserve your love. They turn regular days into epic holidays!

TOOTH FAIRY

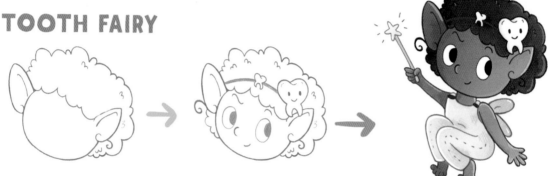

Take your time with the details of this flying legend. Did this feisty fairy ever leave coins under your pillow? If so, draw a gold coin in her free hand.

CUPID

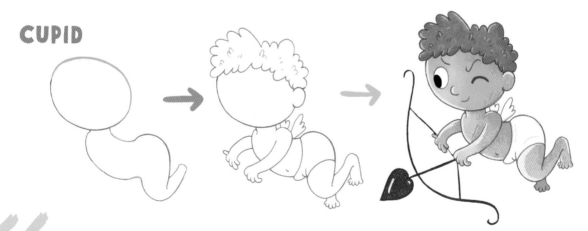

This cheeky matchmaker starts off looking like a snake with a bobble head. With more detail and a bow and arrow made of love, Cupid is ready to celebrate Valentine's Day.

What character represents your favorite holiday? Add a fun twist to any old legend and fill your sketch pad with ideas worth celebrating.

EASTER BUNNY

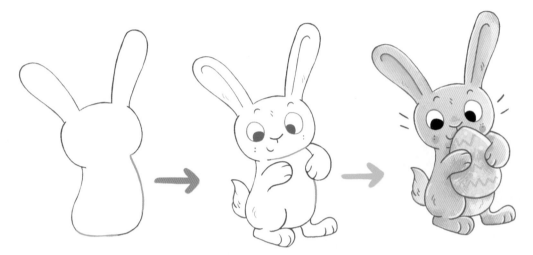

Bounce into springtime with this step-by-step bunny art. Is that egg real or chocolate? It's up to you.

GINGERBREAD PAL

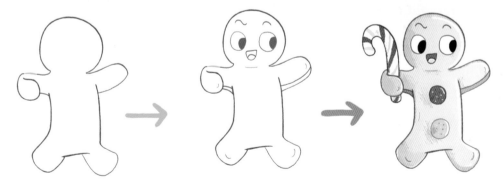

Don't tell this gingerbread cookie that you think he's tasty, or he'll run for his life. Just hand him a candy cane and let him spread his holiday cheer.

How to Draw
Beans

Beans is meow-gical. Make three wishes, but don't be surprised if you're granted nothing but live mice and hairballs.

2.

Add the genie cat's friendly face.

1.

Start with the outline of the genie cat's head.

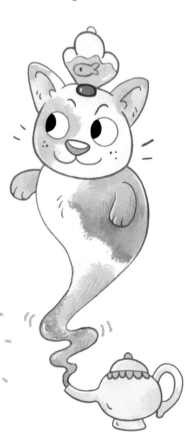

6.

Ta-da! Beans is ready to grant your wish to become the best artist you can be!

3.

Beans needs their
mystical hat.
Notice how it's a
little bit fishy.

4.

Draw the slinky body
next. Beans has arms
and a wisp of a lower
body instead of legs.

5.

All genies need a lamp
to live in. Draw a little
lamp for Beans. I wonder
how many bedrooms
fit inside this one.

How to Draw Eugene

and let his unicorn magic shine!

1.
Start with the outline of the head and body. It's a combination of C shapes. The light blue lines get erased later when you add the mane and legs.

2.
Add a little ear and a hopeful face.

6.
Finally, add some mystical details, like the stars above him and an array of your favorite colors.

3.

Draw the rounded legs. Add a short furry line to show where the hooves begin.

Be your spellbinding self all day long, just like Eugene!

4.

Add the luscious mane and tail.

magical rump!

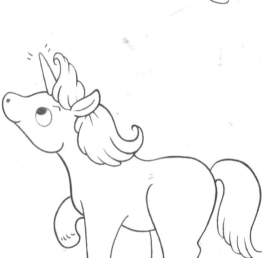

5.

Eugene wouldn't be a unicorn without a horn. Add a rainbow he can stand on.

How to Draw

Meg

Meg the mermaid is effortlessly cool. She never has a bad hair day and her skin is always dewy and glowing.

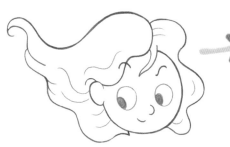

2.

Add her sassy expression and flowing hair. Her hair will be wavy because she's underwater.

1.

Draw a circle with a smaller circle on the left side that will become Meg's ear.

Name a friend that you can't go a single day without messaging:

\- \-

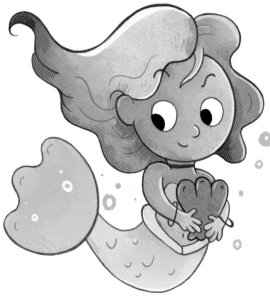

6.

Add color and some bubbles around her. Meg is ready to live her best underwater life!

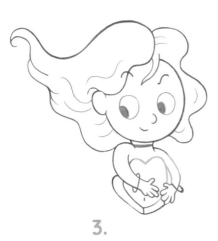

3.

Draw Meg's torso
next, adding funky
bracelets to her arms.

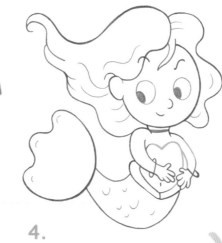

4.

Now add her lower body
and tail so she can swim
about and explore.

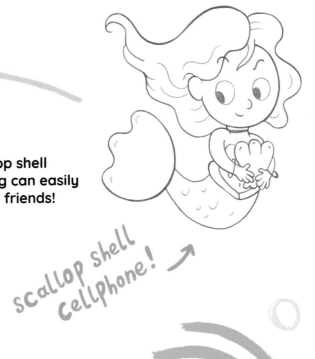

5.

Add a scallop shell
cellphone so Meg can easily
message her friends!

scallop shell
cellphone!

Build Your Own Robot

Create your own robotic friend, fresh from the fun factory!

Add small details, like bolts and antennas, to give your robot character.

For the head, draw a rectangle with rounded corners.

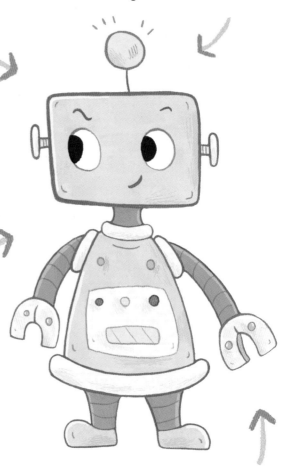

The arms, neck, and legs look like bendy straws. They allow your robot to wave and do the "Cha-Cha Slide"! For more detail, add curved lines to the arms and legs.

Robots are adorable when they have some human elements, like a mischievous grin or a pair of their favorite sneakers.

These claw-like hands are rounded like a horseshow. Be sure to add the bolts on them.

Robot Variations

If you've mastered drawing the first robot, try to doodle your own using these different body parts. Sooo many different combos to choose from!

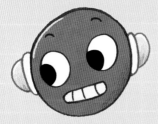

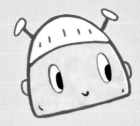

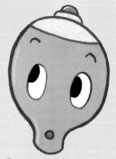

•Heads•

•Torsos•

Just like people, robots have different body shapes and sizes. Play with the proportions to design a unique body.

Drawing different mouth shapes can change your characters' facial expressions.

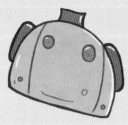

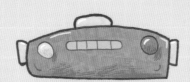

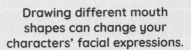

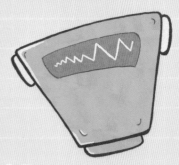

•Arms•

Realistic human hands or sci-fi pincers? The choice is yours! Don't forget the curved line details.

The legs can be powered by fire!

•Legs•

You can also play with the leg proportions to make them super long or short. Your robot could even have no legs at all!

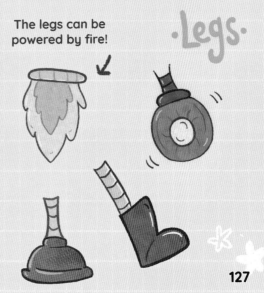

Make a portfolio of all your favorite doodles and beam with pride.

Remember: You can do (and doodle) anything!